Marginalia

I've always been a shy person, embarrassed to exist in the world. As a child, I hid behind my mother's legs and as an ult, I hid behind misguided attempts at objectivity, as if psychological distance could in-

ate me from
w me to
sh incongru-
ior lives fac-
vas afraid to
t I exist. I
could be ig-
away in
adows, may-
ay without
owing up, I
ch thought,
st ground-
from Win-
rth Carolina,
v known pri-
onghold of
ustry. It had
makeup of
ulations. In
s fairly con-
y religious,
ly integrated
South. Af-
orce, my
found our-
oss-country
andmother,
ther tried
profession-
short-lived
rdresser. My
s an audi-
ance com-
rn and tradi-
d principled,
t memo-
ching me
king visu-
h spoken
t time, and
ations on a
iting stories
ernational

and ultimately
transcend the
ences of our in-
ing the world,
acknowledge
thought that
nored, shrink-
corners and
be I could get
having to live.
didn't give too
to identity. My
ed memories
ston-Salem,
which is a small
marily as a
the tobacco
a mostly bira-
white and black
my memory, it
servative and,
but more ra-
than much of
ter my parents'
mother and
selves moving
to live with my
Judy, while my
to figure out
al destiny after
career as a
grandmother
tor for a global
pany. She was
tional, exacting
Some of my
ries are of her
how to read,
al symbols
words for the
pointing out
map to tell me
of her latest
assignment.

ces with unfamiliar names, like Prague and away.
y grew up in Miami in the 1940s to a single lorida,
makes it sound as if Miami is forever lost, sman-
'it piece by piece instead of the distance nother
no education, having been adopted to pi rginia,
ding through a life of physical and emotio n she,
became a mother. I remember a time arou g on a
pping trip with my grandmother to a discount department store, when we approached
checkout cashier, an elderly woman, looked down at me and told my grandmother

CL◀SH

CLASH Books

Copyright © 2020 by Juno Morrow

ISBN: 978-1-944866-67-9

Published by Clash Books in the United States of America.
www.clashbooks.com
www.junomorrow.com

Set in EB Garamond

Cover design by Matthew Revert
www.matthewrevert.com
Typeset and interior design by Juno Morrow

Marginalia

juno morrow

The mule always appears to me a most surprising animal. That a hybrid should possess more reason, memory, obstinacy, social affection, powers of muscular endurance, and length of life, than either of its parents, seems to indicate that art has here outdone nature.

—Charles Darwin

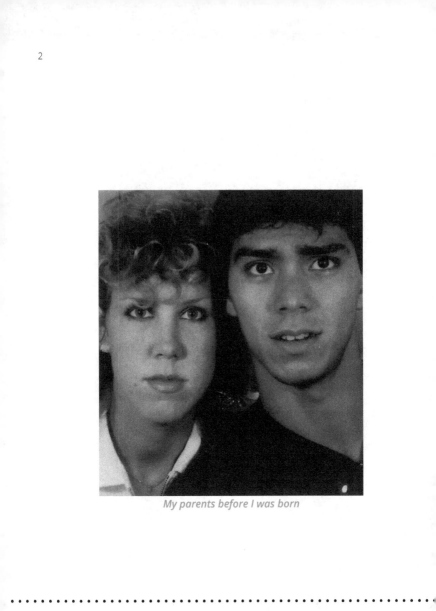

My parents before I was born

I've always been a shy person, embarrassed to exist in the world. As a child, I hid behind my mother's legs and as an adult, I hid behind misguided attempts at *objectivity*, as if psychological distance could insulate me from, and ultimately allow transcendence of, the harsh incongruences of our interior lives facing society. Unsure how I fit into this world of borders, I was afraid to acknowledge that I exist. I thought that if I could be ignored, shrinking away in corners and shadows, maybe I could get away without having to live.

Winston
North

– Salem

Carolina

Growing up, I didn't give too much thought to identity. My parents separated when I was three years old. My mother and I found ourselves moving cross-country to Winston-Salem, NC to live with my grandmother, Judy, while my mother tried to figure out her professional destiny after a short-lived career as a hairdresser. My first grounded memories are from this small city known primarily as a stronghold of the tobacco industry. It had a mostly biracial makeup of white and black populations. In my memory, it was fairly conservative and very religious, but more racially integrated than much of the South.

My grandmother was an auditor for an internationally-operating finance company. She was stern and traditional, exacting and

principled. Some of my first memories are of her teaching me how to read, linking visual symbols with spoken words for the first time, and pointing out locations on a map to tell me exciting stories of her latest international assignment. Places with unfamiliar names, like Prague and Rio de Janeiro, seemed impossibly far away. My grandmother sparked an intellectual curiosity in me that wouldn't soon disappear. Judy grew up in Miami in the 1940s to a single mother. When she speaks of South Florida, she makes it sound as if Miami is forever lost, as if major demographic shifts had dismantled it piece by piece instead of the distance of time and circumstance. Her own mother had no education, having been adopted to pick cotton in the fields of southern Virginia, wading through a life of physical and

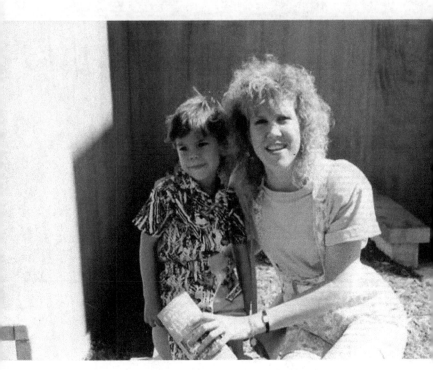

With my mom at Disneyland

emotional abuse that perpetuated itself when she, too, became a mother.

I remember a time around age four or five, going on a shopping trip with my grandmother to a discount department store. When we approached the checkout cashier, an elderly woman, looked down at me and told my grandmother that I was a *pretty girl*. I can easily imagine my grandmother's grimaced reaction. This was the first moment I realized there were other ways of being, configurations of self that I hadn't yet considered. Somehow, I had appeared to be something and just as easily became it. I used

to act out make believe stories after bedtime in the darkness of my room with all my stuffed animal companions. After that, I would stuff several of the smaller ones under my shirt to form two lumps, imagining that I was a girl, in the naive understanding of a child with only my mother and grandmother as references. By the time I was 9 or 10, I was old enough to trawl encyclopedias for fundamental anatomy lessons. I would sit in the shower under the scalding hot downpour, staring at my penis. I would sometimes invert it inside itself and wondered if this was what it meant to be a girl.

During this time, I learned in elementary school about the injustices black slaves had faced at the hands of white enslavers. I knew that black and white people existed and yet no one I knew seemed to fit the description. If I had asked my classmates at the time which category they belonged to, I imagine most giving a fuzzy sort of confirmation, limited by the naive and fragmentary knowledge that children have of the grown-up world, a world that is abstract, free of both context and associations. It seemed to be a time before racial consciousness and yet, everyone was somehow supposed to fit within the black/white racial binary. Thanks to Michael Jackson, I knew that *it didn't matter whether you were black or white*, so the grown-up preoccupation confused me.

The first time that I realized that I, too, had some relationship to race was around 1995, when I was 8 or 9. O.J. Simpson was being tried for the murder of Nicole Brown and white Americans were terrified of so-called *superpredators*. The culture wars were in

full swing. My mother had recently started dating Kevan, a local motorcycle cop. Kevan affectionately calls me *snotty dude* on account of my never-ending runny nose. A man of substantial proportions, he had completed college on a full-ride football scholarship. Kevan was also a dark-skinned black man. This was the only time I remember my mother and grandmother fighting. We soon moved out of her house. I came to learn that the tension was caused not by who he was but by who we were. My mother's blonde hair, fair complexion and blue eyes epitomized whiteness, an apparently self-evident fact that made us white by implication. And yet, when we were together, people softly questioned our relationship. She would tell them that I was her *son* and that the *darker features* came from my dad's side. (My mother enjoys marveling at the diversity of men she's dated—black, white, Asian, Persian, Puerto Rican, Cuban.) When probed further, she would reply that my father *had some Filipino in his family*, her phrasing distancing him and consequently, me, from the burden of being *other*. It was something he *had*, not something he *was*. Occasionally, my grandmother felt compelled to issue an addendum of an unimaginably small Cherokee ancestry from a distant great-grandmother many times removed, a familiar claim in both black and white American families.[1]

I never knew much about the Philippines growing up, other than it was a place that someone in my family had come from in the remote past. When I would ask my mother about that lineage, she would often break things down into negligible

1 See Cherokee blood: Why do so many Americans believe they have Cherokee ancestry? (bit.ly/2UVqRS9) and DNA is Irrelevant — Elizabeth Warren is simply not Cherokee (bit.ly/31W6MML)

fractions, sometimes describing this part of myself as 1/8th or 1/16th. It was something to acknowledge and minimize, a small blip in an otherwise mostly Irish and British ancestral brew. Always ancestry and family, never race. Distant descriptions, not modes of being. When you belong to the hegemonic group, you are allowed freedom from identity, an unhyphenated individual.[2]

Every summer, I would board a plane to spend time with my father in Dallas. He seemed to be everything that my mother was not. He led a bachelor's life, unencumbered by all but his sizable ego. He spoke in obscenities, but never forgot his military discipline. He seemed to have a new girlfriend every time I saw him. He would preach the benefits of being tough, *playing it cool* and *picking up chicks*. His brand of machismo and casual misogyny was something absent from my life back in North Carolina.

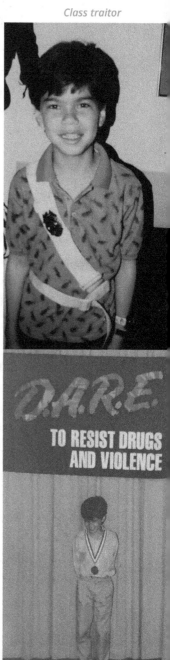

Class traitor

2 See American White People Really Hate Being Called 'White People' (bit.ly/2Hnvtsc)

He listened to this alien sort of music that was unlike anything I had heard before. I could never quite manage to ask him what it was called. After returning to North Carolina, I would attempt to describe the strange cacophony, but no one had any idea what I meant. It wasn't until a second summer of careful listening that the patterns became recognizable, but I still didn't have a name. I sat by my radio, my ear to the speaker and slowly turned the dial one station at a time before discovering one that designated the enigmatic tunes as *rock music*.

Every time I visited, he would remark upon the regrettable softness and femininities he saw in me as being instilled by my mother. To him, each summer meant an opportunity to correct these *flaws* and to undo the past 10 months. He desperately tried to develop my interest in any *manly* sport, while chastising me, telling me the old cliché that boys don't cry. He took away the Barbies and stuffed animals my mother had given me, replacing them with fishing poles and footballs. He dragged me with him to the lake, forcing me to hook the desperately squirming earthworms and sighed when I would cry after accidentally catching something. (I went on to walk the poor fish along the lakeshore rather than taking on the gruesome task of unhooking it, more in need of a friend than a victim.) He went on to *correct* my posture and the ways in which I used my body, limp wrists and crossed legs. Undesirable qualities were derided as being for *chicks* and *fags*. Given his mythological status and distance from my everyday life, I looked up to him greatly and desperately wanted to please him. I felt as if I was an embarrassing failure for him, a project that never came to fruition, instilling a sense of

shame that I've never fully recovered from.

One summer, I asked him about our race, something that I had never quite been able to grasp. He confirmed to me that, yes, we were in fact white. I still wasn't sure how the Filipinx side of the family fit into all this and he made it sound as if it was all overblown. According to family myth, a Portuguese sailor had somehow inserted himself into the bloodline, supplanting any Asianness with the prestige of Iberia. And so, this side, too, had been white.

Despite his identification as a white man, he had faced adversity and discrimination growing up in Texas in the 1960s and

My grandmother, father and aunt

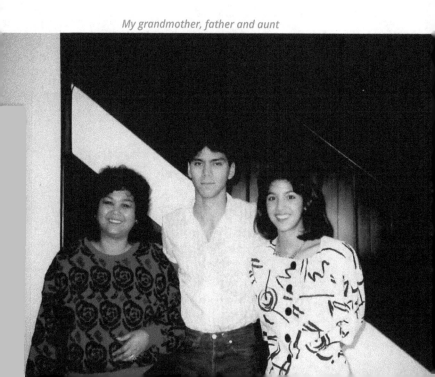

70s. He was raised by an immigrant single mother from the Philippines, along with a younger sister, Sandy, and a younger brother, Bruce. Between their mother's long work hours waiting tables and her declining mental health, they were left to fend for themselves. My grandmother's behavior became increasingly erratic as they were growing up. One day, they came home from school to the carefully dissected components of the television, phones and other suspect electronics dispersed throughout the small apartment. She had been scouring their home for the government-planted listening device, desperate to halt the unnerving surveillance. My father and aunt were able to cope with her decline, becoming self-reliant and independent. The youngest, Bruce, wasn't so fortunately equipped, later going on to serve a 20-year prison sentence. Similarly, my grandmother, on account of her mental health, found herself institutionalized until her death in 2012.

My father with a friend

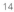

My father enjoys telling stories about the anti-Mexican racism he faced growing up in Texas, despite being neither Mexican, nor Latinx. He often tells the story of going to the door of a high school sweetheart to pick her up. Her father answered the door and bluntly told him that he would never let his white daughter date a Mexican. When he protested that he was in fact white, the father dismissed it as a patently obvious lie given my father's physical appearance. After all, race is determined by the relationship to the dominant group, which is always seeking to extract otherness and enforce exclusion, the one drop rule internalized. My father's coping mechanism was one of denial and defiance; he felt he needed to fully deny any claims of non-whiteness to stand up to people's racism, giving no ground. But arguing with racists, especially in their own twisted logic, is moot for the racialized other. His anecdotes leave me more confused than ever, unsure of the difference between social perceptions and personal identity.

Christmas, 1996

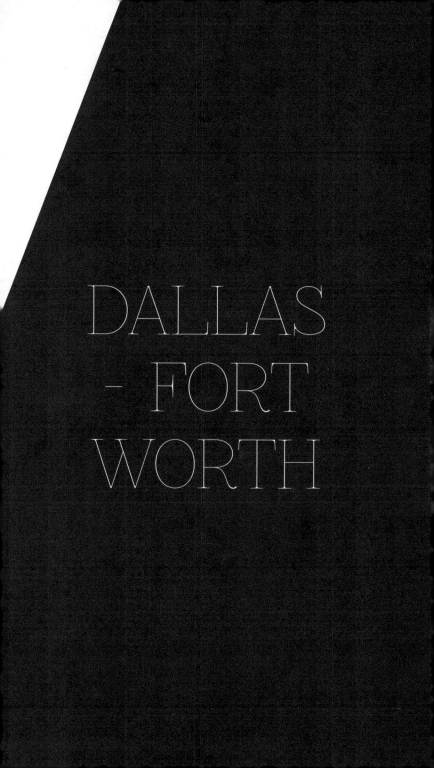

DALLAS
- FORT
WORTH

My mother eventually broke up with Kevan. So, when I was 10, my mother decided that I needed to have a *strong male figure* in my life and so we moved to a Dallas-area suburb where I could be closer to my father. Now successful in his business of telling rich men how to spend their money, my father had bought a house in Plano, an upper-middle class suburb, and we moved into a nearby apartment. A so-called "All-America City," Plano was primarily known for its rigorous schools and safe streets, populated by engineers and money-movers, unrooted transplants and bourgeois newcomers from places like Bangladesh, China and Nigeria. It wasn't the Texas that outsiders imagined and it was unlike anywhere I had lived previously. I had a lot to learn about this new place in which anxieties rested on performance and competition, the trials of the life ahead displacing the immediacy of sustenance and survival.

Without understanding why, the friends I made took on an increasingly second-generation American, often South Asian, makeup. It was around then that I learned to take my shoes off when entering the home and how sandals placed by the entrance became communal apparel, fair game for all (mine often went missing). It was a time in which many of my peers'

With my grandmother. My t-shirt reads "Sega Dreamcast."

cultural identities were becoming recognizable to themselves, a consequence of Chinese schools and masjids. And yet, many of my friends seemed to carry the shame of cultural dissonance that accompanies being a minority. My best friend at the time, Kishore, quickly became irked when his mother would blast bhangra,[3] ashamed of his own cultural occlusion, part of which he felt his own and part *other*. For many, minority culture became ghettoized and private, subject to code switching and minimized for outsiders, seen as a sort of liability impeding the achievement of conventional prosperity. Frustrated by a lack of understanding, many took on "American" names or anglicized their own, softening the edges in the form of acceptability.

3 Bhangra is a popular upbeat music associated with Punjab.

In middle school, we were required to choose between taking band, choir or orchestra. I pleaded with my father to allow me to take orchestra, given my taste for classical music, but misunderstanding, he told me that "band is for fags," as he enrolled me in choir instead (the irony of which was lost on him). The graduated platform we stood on for choir practice was segregated according to vocal range, with sopranos to the right, basses to the left and everyone else somewhere between. In 6th grade, this formed a soft sort of gender spectrum, one that felt increasingly stratified. I remember leaving one summer straddling the divide as a tenor only to return a few months later as a bass. The boys cheered on as each reclassification was announced, seeing this as a celebrated rite of passage, but all I felt was shame and discomfort. This change was emblematic of the larger shifts of puberty, or *becoming a man* in the words of my parents.

The transformation was an unwelcome one, reminiscent of David Cronenberg's *The Fly*, a movie I had recently been shown by my Aunt Sandy, my father's sister. She sought the status of the cool, rule-breaking family member who would spoil me, capitulating to my every whim. But she had overstepped; *The Fly* had traumatized me, putting an end to her privileged position. As hair began to grow out of my legs and face, I imagined Jeff Goldblum's terrified gaze staring a hole into his alien reflection. The coarse, insectile hairs forced their way out of his body and mine alike at a similarly rapid pace. My real fear was of seeing the horrific changes later embraced, as happened to Goldblum's character when the fly mind assumed dominance, leaving only

a decaying palimpsest of the charming scientist. Developing a hatred for my own emerging masculinities, I soon found a repulsion to others. Every boy and man became a mirror of my own tragic condition. This soon became colored by the daily reminders from boys at school that I was a *faggot*, a *queer*, a *sissy*. Clearly, something had gone awry.

My mother worked the night shift and left around 10 PM. Each night, I would sneak out of bed to the polyphonic melody of AOL establishing a dial-up connection. I typed every combination of words that might explain these discordant feelings into AltaVista, then the search engine of choice. I stumbled upon *Susan's Place*, a Web 1.0 message board and webring which was, at the time, the preeminent repository of all things trans and my first introduction to transness from the perspective of trans people. Prior to that, my only exposure was via *The Jerry Springer Show*, trans history revelations becoming the shocking punchline to previously budding romances. Reading through the topics, I tried finding experiences that resonated with my own, but encountered mostly shame and gatekeeping.

Prior to getting medical treatment, trans people had to go through what's called the *Real Life Experience* (RLE), which often meant a year of living in their true gender before receiving any treatment. It was a sort of hazing ritual designed to traumatize people into renouncing their identities. During this year, they were expected to maintain full-time employment, change their names legally and see a therapist. All this, before they could receive the life-saving hormones and surgeries required to

be correctly received as their gender—a year of being read as crossdressers and deviants. The forums were full of horror stories of the trials of the RLE, stories of sexual assault, harassment and failed suicide attempts. At the time, being trans seemed like a death sentence. Additionally, there was an army of middle-aged moderators moonlighting as amateur gatekeepers, waiting to tell you that *no, you are not truly trans*. (I'm not entirely sure what the impetus for policing boundaries is, but the effect is tangible and destructive. Nowadays, we also have resources like <u>amitrans. org</u>, which epitomizes attitudes shifting toward affirmation.)

Back then, sexologist Ray Blanchard's later discredited ideas about transness, elaborated upon by psychologist J. Michael Bailey, still held some credence within corners of the trans community.

Camping with my mom and Kishore

Blanchard's grand contribution was the idea that trans women could be strictly classified into two distinct categories. The first one consisted of so-called *homosexual transsexuals*, described as having an early onset with overtly feminine behavior in childhood and being exclusively androphilic (as in, exclusively attracted to men). The second category, *autogynephilic transsexuals* had a later onset, those who were not exceptionally feminine as children, nor exclusively androphilic and who were sexually aroused by the thought of themselves as women. In the minds of Blanchard and Bailey, both were seen as categories of men, hence the misleading *hetero* and *homo* language that stands in direct contradiction to trans identities. It pathologized difference based primarily on sexual deviation. The former were fundamentally seen as gay men who were too effeminate to attract partners in masc-centered gay communities and so sought transition in order to attract straight men, playing into the classic stereotype of the sex-crazed trans deceiver. The latter classification, so-called *auto-gyne-philic* (love of oneself as a woman) *transsexuals*, were seen as straight or bisexual men with a paraphilia, their transitions fueled by an out-of-control sexual fetish.

Reading the descriptions at age 12, I knew which category I would fall into. My interests were computers and video games, not exactly stereotypes of femininity. During those dormant nights when my mother was at work, I cautiously experimented with her wardrobe, wanting to know what it felt like to be a girl. I tried putting on her makeup too, which left me feeling clueless and unclean, quickly scrubbing it

away with water. (At the time, I reacted to many things on my skin with an acute hypersensitivity, especially things like powders, gels and lotions.) I went to school the next day, my first class of the day being early morning physical education. While in the gym changing room surrounded by boys, a site of incredible anxiety, a classmate incredulously asked the group if I was wearing makeup. Apparently, I had forgotten what I was expected to look like, marked in the color of my shame. My vehement denials were accompanied by the crumpling sort of nausea that paralyzes as it crushes, my color imbued cheeks advertising my guilt and embarrassment. The only other memory I have in that locker room is from the floor, of tightly curling into a crescent, my hands covering my head as the kicks reigned in from the boys I continued to call friends. A few weeks later, I told a girl in my biology class that I pluck my eyebrows. She laughed as she announced it to the class. Seemingly minor incidents brand themselves into my memory, embedding an underpinning of fear and shame that haunts every decision I make.

Age 15 with my grandmother, Judy

My desire to be a girl is bottled up inside, hidden and intertwined with my sexuality. I wonder what it must be like to feel from the inside, to experience pleasure

that matches your desire. I feel attraction to caricatures of femininity, irretrievably entangled with jealousy and longing. I wish I was allowed to have long hair. Masculinity disgusts me. I am afraid of men. I feel bitter at a society that pressures girls to be pretty and encourages them to be passive, denying me the same baggage. I decide that my impossible feelings are markers of sexual perversion, the most acceptable option I can find. Survival seems dependent upon containing my insides—strange sensitivities and forbidden feelings—so I fortify my emotions, building a makeshift wall around myself, my melancholy draped in stoicism.

I join the international club at school so I can learn about difference. I surround myself with friends with unique stories like Ayiub, a fellow socialist whose parents were each both Ethiopian and Yemeni, himself second-generation mixed. (He later went on to become a Randian libertarian and adopted the name Jimmy as a professional alias, something familiar and approachable. This allowed him to pass for African-American, serving his career aspirations with a relative upgrade in post-9/11 acceptability.) There are others with individualized experiences, like Maliha whose Pakistani ethnicity coalesced with her Zambian upbringing and Canadian nationality. There is also River, another sad kid and a self-described lesbian whom I befriend. I feel comfort in our shared desolation and self-hatred. We both come from families that don't talk about their feelings, but we recognize the need to be together with our unwanted affections. (Years later, River came out as transmasculine after realizing that *lesbian* was also wrong.) Forming relationships with people

of diverse backgrounds helps me develop sensitivity to others, expanding the scope of identities and experiences considered valid.

I learn that existing at the margins means always having your legitimacy put into question. Possessing invisible or ambiguous identities means that any claims must be proven rather than tacitly assumed. Being seen as mixed means one is regularly othered by those groups that constitute one's identity. *But you don't look* ⊠, and other reactions of disbelief are often encountered by those with unusual attributes. We worry whether we're enough, as others are unsure what to do with us. The ambiguous other becomes a sort of Rorschach test revealing the extent of an observer's in-group. And so, we seek out others that share our experiences, mutts and outsiders of all kinds.

I meet a girl on a teen matchmaker dating site. She lives across the country in a progressive pocket. We whisper on the phone after midnight, me from inside a spare closet in the darkest corner of my home. She confides to me that she likes girls and I confide to her that I wish I was one. It's the first time I speak it aloud. She isn't appalled, but I know that's because she's special, not because I shouldn't feel ashamed.

By the time I reach 12th grade, my father finally eases my mandatory 3-week haircut requirement and so I stop cutting it. I attempt to dye my hair purple. It comes out black. In class the

next day, a girl who sits next to me asks if I speak Spanish. We have sat next to each other all semester. Hardly anyone at my high school speaks Spanish. People always ask me what I am. I don't know how to respond. When I tell them I'm Irish, they leave disappointed. I offer up the rest of what I know. They are unsatisfied until I say *Filipino. I knew you were something*, they say. Members of every ethnicity and race ask, curious and sure that I am not one of them. I'm left increasingly unsure of what I am, as others push me into opposing boxes.

Houston,
Texas

The first in my family to attend college, I aim to go as far away as possible. Instead, I end up only four hours away at the University of Houston as a political science major. I am drawn to the distance and the diversity, but I really end up there because my grades are trash. UH is primarily a commuter school, but I move into dorms. I apply for the co-ed dorm, but am instead assigned to a semi-segregated one on a boys floor. My first roommate, Kelvin, shows up three weeks into the semester, straight from Lagos, Nigeria. He's the son of a rich oil family. His side of the room is decorated with mass-produced posters of Halle Berry and girls making out, while mine features equally banal political messages and music posters. We're different, but we more or less get along. Early on in the year, we meet Bobby and Cory, two roommates and old high school friends who live two doors down. Cory is a tall fair-skinned white musician with a ginger pompadour and horn-rimmed glasses, while Bobby is a Cambodian-American sneakerhead with darker skin than most East Asians. Thanks to our proximity and shared taste in music, we all become friends. A few months later, Bobby is hanging out in our room and his Cambodian background somehow comes up. Kelvin pauses and then with a bit of shock, asks a question he knows the

Kelvin in our dorm room *Bobby and Cory*

answer to: "Isn't Cambodia in Asia?" Bobby and I look at each other inquisitively. "Yes," he responds. "Wouldn't that make you Asian?" Kelvin asks next. We're shocked to discover that Kelvin had thought Bobby was white all the time we've known each other, a seemingly impossible scenario to Bobby and myself. I am amazed and reminded of just how racially attuned us Americans are, always ready to mark difference, delineating boundaries of being.

College is a generally much happier time than high school, free from the prying eyes of my parents and that bubble of economic privilege. I change majors no less than 5 times, moving from political science to graphic communication, photography and art education before finally settling on media production. I find that making things helps build my confidence and I find great satisfaction from it. During this time, I go to visit Jaimie, the girl from the closet, at Smith College, a women's liberal arts college in Western Massachusetts. As one might expect, the school is a bastion for queer women and ironically, an incubator of transmasculinity.[4] Jaimie's roommate and dormmates throw a party for her birthday.

4 *Transmasculine* is used to describe people that are assigned female at birth and transition toward a masculine form. It is inclusive of trans men and nonbinary trans people of this experience.

Pleasantly warm after drinking far too many PBRs, Jaimie and I go to sit on the Victorian porch while she smokes a rolled cigarette. It's November in Western Massachusetts and she charms me by spitting on the deck, showing how it instantly

Jaimie's birthday party

freezes from subzero temperatures. We talk through our intertwining histories, past, present and future. Despite the cold, I feel at home there, safe from masculine aggression.

After returning to Houston, I plan my move into a studio apartment for my third year of school. Safe from the supervision of my parents, RAs and roommates, I make a vague plan to do a trial gender transition, although I could never say that aloud, let alone survive a year or more of scrutinizing therapy and RLE. I pay hundreds of dollars to a sketchy pharmacy in Vanuatu for blister packs of hormones, the kind you pop out from sheets of plastic and aluminum foil. I meticulously calculate dosages from available literature (and DIY internet groups), but it still feels like a capricious decision, an inconceivable action to rationalize. I don't know what my end goal is, too afraid for even internal dialogue. I tell Jaimie of my plans without really talking about why. She somehow understands and is supportive, but my coyness on the subject shuts down any dialogue and we revert to silence. It isn't a big deal to her either way, and so there isn't anything left to talk about. After just two or three weeks, I stop taking the medications, seeing my feelings as impossible and my actions as self-destructive. The following semester, Jaimie drops out of Smith, moving to live with me in Houston after a few months abroad in Costa Rica and Mexico.

3/22/07 sylvee, arial

Houston's endless sprawl and humidity was never a good fit for us and so, after I graduate, we decide to move to New York for a brief one-year stint before hopefully moving abroad. Before moving there, neither of us really like New York; we find it dirty and intense, but also irresistibly magnetic. We feel as though we need to be someplace where things are happening and NYC is as

sure a place as any. I have vague intentions to work in television or film production, but what I really crave is an opportunity to start again somewhere new. We are sad to leave our friends behind, but excited for the discoveries ahead. Surprisingly (or not), we end up loving New York. It's a hard place to live. Every task feels like a struggle. Even finding a sublet becomes a challenge, sometimes requiring multi-round interviews and references, but it's hard to find a city more inspiring. There's a seemingly never-ending supply of smart, talented and interesting people doing amazing things. It feels like survival of the fittest, pushing you to be stronger or get out. We stay on long past the expiration date.

Browsing the internet one day, I discover that consumer-level DNA testing can uncover ancestry. Intrigued, I request a kit from a popular testing service. I spit into a vial and stare inside, unsure how much it can reveal. New York state law bans submissions and so I take the PATH train under the Hudson to New Jersey, eager to substantiate or discredit family mythos. I think back on the questionable stories from my childhood, wondering what the relationship is between what my family told me of our background and what others see. After a few weeks, the results come back. I know this doesn't change who I am, but things feel different. I treat it with skepticism, but I know it offers truth, too.

I feel validated in my unspoken skepticism of Portuguese sailors and infinitely-great Cherokee grandmothers. It makes me consider the equivalency and purposes of those myths. The Cherokee myth serves to legitimize manifest destiny while allowing white Americans to conveniently insulate themselves from accusations of racism, while the Portuguese sailor serves to

Juno	100%
European	**70.9%**
● British & Irish	53.4% ⌄
United Kingdom, Ireland	
● French & German	5.3% ⌄
● Scandinavian	1.0% ⌄
● Broadly Northwestern European	8.5% ⌄
● Broadly Southern European	1.2% ⌄
● Broadly European	1.5% ⌄
East Asian & Native American	**28.7%**
● Filipino & Austronesian	25.9% ⌄
Philippines	
● Broadly Chinese & Southeast Asian	2.8% ⌄
● Broadly East Asian & Native American	0.1% ⌄
Sub-Saharan African	**0.2%**
● Congolese	0.1% ⌄
● Broadly Congolese & Southern East African	0.1% ⌄
Unassigned	**0.1%**

elevate one's class, carving out space in a racialized aristocracy.[5]

Expecting basic fractions, I ask myself how it's possible to be such an odd in-between, 70.9%, 28.7% or even 0.2% of a thing. I come to learn that although we inherit exactly 50% of our DNA from each parent, that 50% is a semi-random combination of their parents, so we can likely end up with more or less than 25% from each grandparent. Describing people as if each aspect took up a percentage conjures up butcher cut diagrams, as if people could be cleanly carved into constituent parts with discrete origins, a Persian stomach and a Tuscan tongue.

5 The Philippines is a country in which skin whitening soap is the norm, partially a consequence of the class stigmatization of outdoor labor and partially as a consequence of the 300+ years of Spanish colonization and their caste system. However, unlike the American system of racial purity, the situation was a reversal in a country that was overwhelmingly populated by native peoples, some degree of racial privilege was extended to those possessing any European blood. *Blancos*, a group that included Filipinx *mestizos*, were not required to pay any taxes, and those with Chinese ancestry paying additional taxes, with full blooded *Sangleys* paying four times the rate of *Indios* (the largest indigenous group). Following the establishment of American dominion over the Philippines, the Americans instituted a new paternalist racist culture for their "little brown brothers," as white Americans called Filipinx people.

My mom with Jaimie during a visit

After years of codependency, Jaimie breaks up with me, u-hauling with Margie, my friend and former coworker. I harbor neither jealousy nor resentment, but I feel broken, directionless and alone. At least she didn't put up any custody claims for our neurotic, but lovable cream-colored cat, Arial. (I later find out from Jaimie and a mutual friend that Margie died of a heroin overdose a couple years after their breakup.) After four or five months alone, I survey the NYC dating landscape via OkCupid. Attracting straight girls feels impossible and I have difficulty performing masculine gender roles that might increase my marketability. Sex is similarly impossible to navigate, as I feel forever out of sync. Attracting boys is never hard and I wish I could work my way past my disgust for masculinity. Following five years of tight attachment, I feel unsure of who I am, so I cut my hair short again, thinking I can rework myself in a more masculine image.

Apathy lies

With six months of living expenses in savings, I quit my dead-end market research job so I can focus on my aimlessness. I show up at random meetups, like philosophy discussion nights at a gallery in Bushwick and Reddit meetup groups. I hope to establish human connections, but opening up to strangers is inconceivable. So instead I get wasted, frequently waking up tearfully drunk on the train well past my stop, vomiting in trash cans and all sorts of public spaces. I'm drowning in self-absorption as I masochistically relish the depths of this emptiness. One night, I somehow regain lucidity as I'm being led by the hand on a long walk through fuzzily familiar Bushwick blocks. A gentle but disheveled stranger is leading me back to her apartment. I realize that the playful twirling of our intertwined fingers and her wandering touch is almost certainly communicating sex. I feel panicked as I realize that this momentary connection is meant to be physical and I bluntly stop it before it goes too far. The ensuing awkwardness deepens my sense of disconnection and the pattern perpetuates itself.

Around this time (2011), I am invited to a party in Bushwick by a flirty acquaintance hoping for something more. She works at

a reputable feminist sex toy store and her party draws a diverse queer crowd. Feeling awkward in the crowded and sweltering railroad apartment, I find myself drifting toward the wall and make eye contact with another wallflower. We introduce ourselves and our relationship to the host. I don't remember how we get there, but they tell me that they're *genderqueer* and ask if I'm the same. I'm taken aback by the directness of the question and the confidence with which it is asked. It's a term I'd heard here and there (mostly on Tumblr), but never given any real consideration to. I surprise myself, responding with *I think so*. As it had when I was a child in the store with my grandmother, the world seems to open up with possibilities. *Genderqueer* seems to describe the familiar in-betweens, feelings of yes and no, of being everything and nothing. The convenient encapsulation is enticing, but I feel a bit uncomfortable using *queer* to describe myself, unable to disambiguate the childhood slur from the anti-assimilation symbol.

I meet a tall person on OkCupid, sending her a message after I notice her profile says she speaks Visayan, the second most common language in the Philippines. I'm curious why, since she's white. After telling me about her abysmal time in the Peace Corps spent in Negros Oriental, a mostly rural province in the Philippines, we set up a friendship date over tea. (Her profile says she's gay and everyone thinks I'm a boy.) She arrives by bike with perfect posture, which she tells me is due to the rod in

her spine from a scoliosis surgery in her teens. We connect over shared interests in language, systems, sexuality and gender. We hang out a few more times over the next few weeks. I invite her to my next-door neighbors' party and we use the occasion to lower inhibitions and talk more intimately. She confesses that she is actually bi. I ask if that means she is only attracted to the binary categories of men and women, which she confirms. We decide she is *boysexual*, interested mostly in boyish-presenting men and women. I tell her that I actually identify somewhere in between the male-female binary. It feels nice to be this open, but I worry

Blake, a.k.a. tall person, in El Nido, Palawan, Philippines

that she isn't attracted to me. Still, our relationship transfigures into the romantic and sexual. It is unconventional and deeply rewarding, but I will never forget what she said in the four years that follow. Our strange connection adjoins an equally strange silence.

I'm torn over how much of her business I want to spill. She claims to dislike trans people on account of *artifice*. One day, she confesses that trans people make her feel uneasy and I know exactly what she means. It's the moment when internalized transphobia is projected externally, a reminder of a path you'd rather look away from. She sometimes describes herself as a trans person who doesn't want to medically transition. She takes on masculine names and he/him pronouns with others, but is adamant that I not change how I address her and I respect her wishes.[6] She loves her body, but hates being seen as a woman. Our gender nonconformity aligns well, but I keep my dysphoric feelings at arm's length, unable to erase her ideas from my mind.

Seeking drastic change, we both enroll in grad school—I go to Parsons for a technology-driven design MFA and she goes to the University of Hawaii to pursue a linguistics PhD focusing on endangered language documentation. Worn down by several years of aimless and unsatisfying work, I hope to grow

6 I would be remiss if I didn't point out that this changed after I wrote this. I discussed this with him and asked if I could call him by his current name and pronouns. We evolve at our own pace. I left the old name and pronouns in regard to our evolving understandings and respecting his stated wishes that people not change on his account.

intellectually and creatively, expanding my repertoire by incorporating code and technology. Meanwhile, her long periods of fieldwork to remote corners of Indonesia further strain our connection, exhausting the remaining elasticity. It ends with a fizzle instead of a tear.

In the time that follows, tech platforms like Facebook and OkCupid expand to allow nuance and diversity in gender identity. I take a step forward, changing my online gender to *nonbinary*, a term that largely supersedes *genderqueer* with mostly overlapping connotations. I survey the landscape using the safer spaces of the internet, wondering if it's safe enough to venture out. After graduating from Parsons and lucking out on a tenure-track position as a game design professor in CUNY, I allow my wardrobe to shift toward androgyny. I make a list of all the names I like; I have always made these lists, but I put more thought into it now. It includes a few masculine names so I can tell myself its purpose is isolated and purely aesthetic.

<u>Favorable Names</u>

Alex/Alexa/Alessandra/Aleksandr/Alexandra
Anubis
Anya
August
Azrael
Cam/Cameo/Camera/Camry
Dante
Demitry
Desiree
Destiny
Emi/Emmy/Emy
Emma
Gavin
Hazel
Iris
Julai
Janus
Jules
June
Juniper
Juno/Juneau/Junot
Kai

Ken
Lucian
Marie
Marina
Nika
Oleander
Rafael
Red
Scarlet
Sofia
Sophie
Tessa
Tiger
Valerie/Val/Valecia
Victor/Victoria
West
Zoe

It becomes increasingly difficult to ignore the enduring effects of testosterone, poisoning my body as it defiantly etches itself into my structure, relentlessly chiseling away at my crumbling construction. I study my hairline's steady recession at obsessional levels, terrified of plausible projections. My face takes on inclines and angles as I look back, recognizing just how much I've lost. Once again, I order shady pills from the internet, this time from India. I hope to walk back the dysphoria, slowing my descent into an ever more masculine form. I think to myself that maybe if I can treat the symptoms to control my dysphoria, I can go forever without really having to address who I am. I try walking the line with a few antiandrogens and a low-dose estrogen, hoping that nobody really notices. As I proceed, I notice a pattern in conversing with colleagues, friends and students alike as they struggle to avert their falling gaze. They strain themselves as they try not to notice my chest taking on an unexpected form. Again, I shrivel away from a path forward, teetering back and forth, unsure where I'm going.

I get involved in radical activism after Trump's ascent, desperate for a means of rendering resistance. I show up at anarchist and labor events, meeting fellow travelers and making genuine connections along the way. We fight an uphill battle for immigrant bread workers and develop sanctuary spaces in our communities dispersed throughout Brooklyn and Queens. Increasingly, I find myself in spaces in which pronouns and predispositions are not a given, imparting the freedom to choose for oneself. I've

long felt ambivalent about using singular they/them pronouns, understanding the initial grammatical discomfort many feel. When people are eager to respect your identification, asking them to regard your distinctions no longer feels like a burden. Asking people to call me *they* starts to lose the feeling of being an imposition. Identification outweighs grammatical antipathy, relieving me from habitually apologizing for being.

We are expected to encapsulate so much of our identities and experiences in what we call ourselves. Claiming an identity feels impossible when no one sees you as you are. Those that slice their experiences thin are often dismissed as divisive or self-involved. Labels create boundaries as much they create community. Still, we strive to find our place in a world of borders.

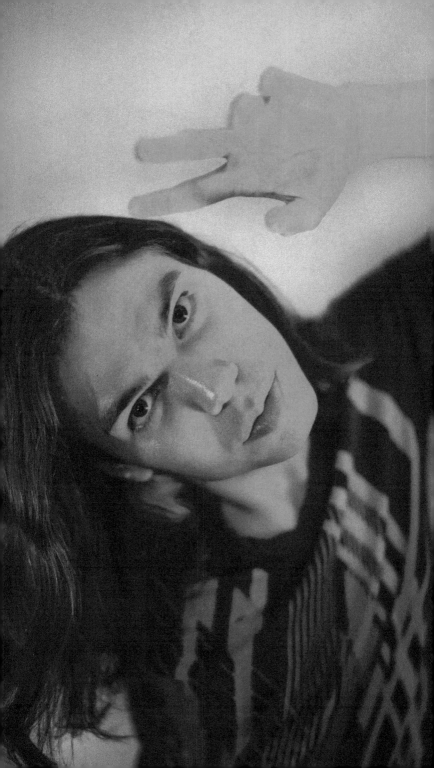

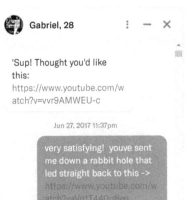

Gabriel, 28

'Sup! Thought you'd like this:
https://www.youtube.com/watch?v=vvr9AMWEU-c

Jun 27, 2017 11:37pm

very satisfying! youve sent me down a rabbit hole that led straight back to this ->
https://www.youtube.com/watch?v=Vq1T44Op8eo

Press enter to send

SEND

I begin messaging with a transmasculine graphic designer on OkCupid. They tell me their name is Gabriel and ask me on a date. I'm excited, but also anxious, wondering whether T (testosterone) will interfere with attraction, my queerness in question. We go out for dinner and drinks at a casual tiki-themed spot in Crown Heights. They show up wearing light wash denim overalls covered in impressively cute and interesting patches. It's crowded on a Friday night, so we sit out on the patio under a light drizzle. They are kind and complex, critical and clever. We quickly identify our commonalities as we explore our parallel paths. We find ourselves walking back to their place nearly two miles away, stopping to pet sociable kitties along the way. As the best dates do, it feels welcomely unending as we spiral into each other, embedding ourselves deep into the other. We lay in bed spilling our souls, evenings into aeons. Our conversations are earnest and open, unguarded explorations of our experiences and acculturations. It feels as though a lifetime of disorder is unrav-

eling, illuminating elements and influences.

Among the many beautiful things Gabriel shares is *Whipping Girl* by Julia Serano, a sort of transfeminist manifesto and Trans 101 for trans people. We work our way through other must-reads by trans authors, books like Imogen Binnie's *Nevada* and Casey Plett's *Little Fish*, writings from Gwen Benaway (bit.ly/3byIzk5), Akwaeke Emezi (bit.ly/2USRnLJ) and Kai Cheng Thom (bit.ly/39yE0oc). They open me up to possibilities of difference, unconventional narratives, experiences outside

of dogma. Prior to this, most of the *official* narratives I had encountered were of the traditional, heteronormative variety. *Real* trans people were straight. Trans women knew they were *women trapped in men's bodies*, having always known and *never* doubted. Trans people are often forced to voice our feelings and desires with the reason and conviction necessary to be taken seriously and to see ourselves emerge (think RLE and medical gatekeeping). Meanwhile, I had never known how it felt to be a man or a woman, only myself. For most of my upbringing,

With Gabriel

people had assumed I was a normal-enough straight cisgender male. (Although my dad once slipped, telling me that he and my mother were greatly relieved when Jaimie and I had entered a relationship.) By and large, we trust that we are normal growing up, rationalizing away anomalies until the dissonance becomes undeniable. Where our qualities happen to be congruent with expectations, rationalization and compartmentalization become all the easier. These new narratives resonate and address my insecurities. As possibility creeps toward viability, I feel myself spilling through the seams.

After a night spent drinking, I collapse in Gabriel's hallway crying. My illicit meds are running out and I am distraught at the idea of testosterone destroying what's left. Gabriel comforts me in a

way that only they have been able to. I tell them what I'm feeling and they tell me about their experiences at APICHA, a local community health center. Their confidence and compassion for me confirm my own and I make an appointment at the clinic, feeling as though legitimacy is finally within reach and ready to face myself.

Gabriel helps me try out a new name. The rhythm of Juno, a name I have loved since childhood, and my mother's *maiden* name, Morrow, feels delightful. The *Juno* seed was planted by an early childhood love of Greco-Roman mythology and Juno Reactor, an electronica group whose intoxicating beats had drawn my attention in middle school. Meanwhile, I had always

hated every aspect of my birth name—first, middle and last. Being designers, we both start imagining the reflective interplay of the letters M-O-R and R-O-W, adding to the attraction. We cautiously commit to using it around their friends alone while I feel it out for compatibility (despite years of knowing it's right). I stutter when asked for my name and struggle to remember. I worry about inconsistencies. I feel like a failure. Finally, **I fuck up again**, giving out the wrong name when asked. I know now that I can't compartmentalize myself without feeling like a fraud.

The seemingly simple question of *do you want to be X* is sometimes so hard to answer, our desires entangled with doubts and a lifetime of socialization. Gabriel and I discuss the following thought experiment:

1. You are trapped on a desert island.
2. There is a button you can press to instantly and painlessly exist as X (state of being in question).
3. Since you are trapped on the desert island, you never have to justify your decision to anyone.
4. Do you press the button?

Do I press the *Juno* button? Yes, I do.
Do I press the *girl* button? Yes, I do.
(Does Gabriel press the *flat chest* button? Yes, they do.)

The button becomes our de facto standard for knowing ourselves and our desires.

Suddenly, I no longer feel restrained by the lifetime of doubts that this isn't who I am. I recognize that the only thing holding me back is the difficulty of enacting change, which I find to be unacceptable rationale for abstinence. Later that night, I follow in Gabriel's footsteps, impulsively navigating to the name change settings on Facebook. There, I am faced with the following:

Please note: If you change your name on Facebook, you can't change it again for 60 days. Don't add any unusual capitalization, punctuation, characters or random words. Learn more.

I welcome the warning, knowing I need the constraint. Recognizing the necessity of pushing myself over the edge, I click confirm, feeling warm with excitement and dread.

Things have changed since the covert late night research I did in middle school. The theories of Blanchard and Bailey have been largely discredited and forgotten, the *real-life experience* giving way to *informed consent*, trusting people to know their own experiences. Finally receiving treatment from a doctor resolves my seemingly endless doubt with external validation. Each day brings greater relief from dysphoria, feeling like I can finally breathe. After years of mulling it over, I finally have bangs cut which make me feel 50 times lighter. My skin softens as my body adopts a comforting direction. My face takes on feminine features as subcutaneous fat subtly redistributes and I can finally smile at myself in the mirror. The smiles seep into sundry corners of my life and others take notice.

At the same time—socially, every day is a struggle as I slog my way through, aligning aspects, outside with in. It isn't easy—I find strangers and familiars alike staring, seemingly asking themselves the well-trodden question, *what are you?* Facing my family is one of the hardest things I ever have to do, but I do it nonetheless, knowing they will find out one way or another. To my surprise, my father immediately understands and my mother never does. He calls me late one night sounding drunk and emotional, an unseen combination. Guilt-ridden and tripping over his words, he gives what I make out to be an apology (in his own way, one of few words and long silences). No longer needing to affirm his own toxic masculinity, he hardly resembles the man of my childhood. Meanwhile, my mother tends toward denial, struggling to integrate new knowledge up to this day.

Despite facing challenges, my worst fears never come to fruition. Nightmare scenarios of excommunication and violence drift from consciousness as confidence builds; I notice a shift in my treatment. This allows me to see myself differently and I feel a change. I start to notice the body odor of men from far away, on the train and across the street. Gabriel and I jokingly add it to our unwritten list of unfortunate superpowers. Somehow, my aversion to men starts to slip. Childhood admiration for men is recontextualized, transmuting itself into a different attraction that had somehow always been there, obscured beneath the surface. The shift is subtle but tangible. I am still attracted to women, but it feels somehow different as I start to disambiguate attraction and envy, separating desires of proximity from being. Queer feelings are often confusing as we struggle to decide whether we want to *be* someone or to *be with* them, relationality both internal and external.

As strangers start to stare less often, they also approach me with an unexpected familiarity. I receive compliments and people of all sorts seem less afraid to smile in my direction. Men (literally) trip over themselves to help me up one day when I slip on the train. It's a strange experience to suddenly find doors being held open for you when you're perfectly capable. *Ma'ams* replace *sirs*, but there is no clear delineation between the two as I teeter in the interstices. My drifting social treatment and self-image carry my identity along with it, fluid and flexible. Gabriel and I discuss everything, and they joke that they are going to crack my *woman egg*.[7]

7 Egg is a common meme among trans communities on the internet, used to refer to people who haven't yet realized they are trans. See example 1 (bit.ly/2Ho3Dfs), example 2 (bit.ly/38ss0nZ)

Before returning to teach in the fall, I struggle with pronouns. I know that expecting students to call me *they* is optimistic at best. Most people have trouble grasping they/them pronouns, allowing themselves to slip to *he* (at least for those that previously assigned he/him pronouns to me). Whenever it happens, *he* feels like a punch to the gut, a distracting reminder of the distance between myself and their ideas of me. Even when people catch and correct themselves, they often tell me that it's hard for them, volleying back the onus of feeling bad. *She* feels fine, but never much like me. I decide on a compromise. On the first day of classes, I tell my students my pronouns are they/them, but also tell them that she/her is fine. The students I've had in previous classes continue to call me *he*, with the less familiar faces gravitating to *she*. Almost never am I referred to as *they*. Changes in the way people perceive me permit freedom from internal compromise.

Transitioning seemed to me an insurmountable task. How we see ourselves is necessarily relative and situated in the human geography and relationships of our lives. Knowing that I wouldn't be alone and that I would be loved and supported even if I came to regret my decision was all it took to dismantle my shell, exposing me to the sometimes brutal environment of our society. The more people called me *she*, the less strange it felt.

IN A VACUUM, I AM A PERFECT CIRCLE.

CIRCLING

Gabriel and I plan a trip to Chefchaouen, a small city in northern Morocco known for its winding alley streets and azure walls. The blue is thought to originate with a historical population of Jewish refugees fleeing the Spanish Inquisition. Enamored with the images we see online, we don't stop to think through the trip until after we book our non-refundable tickets. As one might expect, Morocco does not have a great record on LGBTQ rights. I try comforting myself by recognizing that the penalty for queer expression is limited to only 3 years of prison, a significantly less harsh punishment than many of its neighbors. I try searching the internet for other trans people's Morocco

travel experiences and instead find a video of a trans woman being beaten unconscious in the street by a mob before being dragged off by the police. The 2015 video is taken in Fez, the city we are flying into. We don't expect anything to happen to us given our privileged tourist status, but it's nevertheless terrifying. I decide to travel in boy drag to match my passport, putting on my most masc clothes, pulling my long fuchsia hair back and covering it as best as I can with a backwards baseball cap. I stop shaving to see what remaining facial hair I can scrounge up before venturing out. It feels humiliating, but I'd rather not risk myself.

We board a TAP Air Portugal plane at JFK, Fez-bound following an extended layover in Lisbon. At Moroccan immigration, the officer takes our passports and gives me a hard stare. She makes me remove my cap, revealing my mangled hair and deep M-shaped hairline normally covered by my bangs. She smiles slightly in a way that seems to apologize for having made me expose myself. Gabriel faces an even harder stare, as the officer quickly glances back and forth between Gabriel and their passport page bearing an old photo with feminine designations. The officer takes on a stern expression as she tells us to wait while finding a supervisor. The supervisor comes over and clearly identifies Gabriel's facial features in person and picture. The supervisor seems to tease the officer for the mistake as we are stamped in and waived away. We leave our taxi at the gates of the medina, our luggage in tow. Less than 30 seconds after we enter, we are called *homos* after ignoring one of the numerous competing touts. Luckily, this is the worst it ever gets. Fez being a tourist mecca, the competition for tourist dirham is fierce. The streets are strained with class tension.

Walking through the sometimes shoulder-width streets, touts approach us from all angles, looking for a way into conversation. They ask where we are from before inevitably venturing a guess— sometimes Spain or France, other times China or Japan. Gabriel gets a lot more *ni haos* than I do, but we surprisingly both get alternating guesses on opposite ends of Eurasia. It becomes a strange revelation of ambiguity that would never happen back home, at least not with the same frequency.

I'm reminded of a short stint working the reception of a Brooklyn hostel. International guests would often tell me *I don't look American*, prompting the usual *what do you mean*. I eventually tired of playing naive interrogator, knowing exactly what it meant. (In hospitality, a smiling mask is your uniform, unyielding and outwardly immune.) Reflecting on this makes me glad to live in *my* New York, a place in which diversity is the norm and where everyone is assumed to be *something*. For the most part, no one seems to ask me *what I am* or *where I'm from* anymore (at least not in that racially-charged way).

We make our way north through Chefchaouen, followed by Tétouan, further north near the Mediterranean. As we depart the tourist trail, each stop feels more relaxed and friendly than the last. In Tétouan, several locals ask (in English) if I am Moroccan, which I find most puzzling of all. I wonder if they think I am Gabriel's guide, unsure what the norms are here. Moroccans look fairly heterogeneous, but I notice a pattern of lighter skin and eyes as we approached the Mediterranean. After crossing the fortified land border into the colonial holdover of Ceuta, Spain,

we're relieved to finally resume our mutual affections and normal gender expressions. Crossing the cultural fault line feels like interdimensional travel making both sides seem less than real.

A week or two after returning to New York, my dad plans to visit for a weekend. Ostensibly, it's for work, but I never remember him traveling for work. Our relationship has been disintegrating for years and it will be the first time I've seen him in over a year. I am dreading it for both of us, unsure of how easily broken old habits will be. However, since my childhood, he has matured, growing self-aware and finally able to see past his insecurities and the constant need to prove himself. His own widely-disdained father had been an ego-driven gambler of small stature who never showed women respect. He swore he would never be like him despite having met him halfway. Slowly realized this, he became a much better father to my very young half-sister and step-brothers than he ever was to me. He even started saying *I love you* after a bout with cancer a few years prior. Still, every time I visit him, I'm reminded of everything I hate about where I came from. Unfairly, I project these feelings upon him, subconsciously associating him with narcissism and toxic self-interest. At the same time, I sense an opportunity for reconciliation, however unlikely it may be.

I meet him at his ostentatious hotel on Central Park South. When I arrive, he's in the hotel bar with a Coors Light in one

hand and his dip tobacco spitting cup in the other, joined by his macho right-hand man, Guy, and his wife. After the obligatory crushing handshake and small talk with Guy, my dad and I leave to go out to dinner. Our single biggest commonality is food, so I plan to introduce him to delicious new foods while hoping to connect. We take the subway to K-town for Korean fried chicken, which is no small feat given his visible anxiety regarding confined spaces, which he tries masking. Visible sweat builds as his eyes dart around and his body language changes. It's a rare glimpse of vulnerability, seeing him out of his element, instead in mine. The restaurant is loud and uncomfortable, the kind of environment in which I struggle to communicate. Unnerved by the silence, he starts chatting with the rowdy table next to us telling them about how he came to visit me, calling me his son and acting as if nothing has changed. The table and I exchange awkward glances at this and they continue their back-and-forth banter with my dad about alcohol and food, laughing and enjoying themselves while I contract in the corner. I feel humiliated, ignored and alone, again a child with no power and nowhere to go. Even small things feel monumental when examining them before the backdrop of our history and relationship. Thankfully, the food comes, but it's barely enough to contain my feelings, which are nearly bursting at the seams. I say nothing, fiercely telegraphing my displeasure and disappointment at his obliviousness. Finishing dinner and stepping outside, he tells me that he wants to meet Gabriel, which surprises me. We make plans for him

to meet me and Gabriel early the next day before we head to Flushing for lunch. I ask if he is okay to take the subway two stops back to his hotel, which he confirms following my detailed instructions.

I slump into my subway car heading the opposite direction, still simmering with distress. I start drafting a text, seeking the best way to tell him how I feel without pushing him to become defensive. I want him to know how his words affect me and our relationship without asking for his respect.

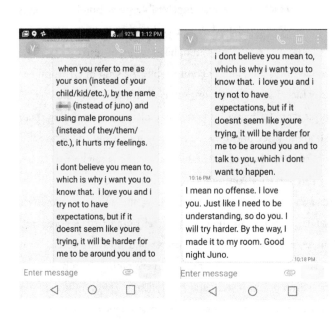

The next morning, as he is on his way to my apartment in Bushwick, I ask Gabriel to be diplomatic. I know they know they're already aware of it, but they're fiercely defensive of me

and I haven't given them the best impression of my father, mostly through painful recollections, tearful sobs and downcast eyes. He makes it to my apartment and I welcome him into my home for the first time since he dropped me off at my dorm 15 years earlier. After brief introductions, we take a car to the restaurant. I hope to introduce him to xiaolongbao, the Shanghai-style steamed dumplings filled with hot soup and meat (typically pork), a favorite of mine and Gabriel's. We both try to give him the rundown of our differing techniques of eating xiaolongbao, which must be eaten carefully to prevent spillage and (inevitably) burning your mouth. It soon becomes clear that, unbelievably, he doesn't know how to use chopsticks. I replay all the memories growing up when we would eat Chinese food, seeing him only with a fork. When the steaming bun platters come out, he does his best before stabbing one of the dumplings, immediately squirting hot soup all over his shirt. The vulnerabilities start to add up, humanizing him. After saying goodbye to Gabriel, we take a long subway ride to DUMBO for a quick walk around the waterfront before heading back to his hotel so he can change clothes before dinner. A few days earlier, I had booked a table at a fancy steakhouse, the kind I almost never visit. (I'm cheap and don't eat out much.) On the way to the restaurant, he asks me, "It doesn't bother you when people stare? I see them staring at you, like on the subway, and it upsets me. I want to ask them what the hell they're staring at." *Of course*, I tell him. I am startled that he is defensive of me as I wonder if this has always been the case.

We arrive at the restaurant, a family-owned Italian-American place in Williamsburg, the kind featuring wood paneling and framed photos of Rudy Giuliani. While waiting to be seated, we order drinks from the restaurant bar, both eager for an easier way through the experience. The dining room is extremely spacious by New York standards, with no more than 10 tables, each separated by around 5 feet. Our server recommends the 40 oz porterhouse for two, which we both happily agree to. After devouring a delicious appetizer of thickly sliced maple bacon, I tell him about how my best memories of us together are of him grilling steaks on the patio before serving them up. From there, we start talking about the best steaks we've ever eaten. I tell him about how, a few years earlier, I had perfected my techniques salt-dehydrating, flash frying and broiling prime rib. The conversation feels easy as we work our way through a second round of drinks. Our rare steak comes out on a sizzling platter in a pool of its own juices. Our butter knives easily partition the meal into bite-sized chunks, each seemingly more flavorful than the last. Our audible *mmm* sounds last until all that's left is the bone with a few errant slivers remaining. Our server stops by to tell us that they encourage using your hands at the very end to get the last valuable morsels. My dad and I simultaneously look at each other and, following his approval, I pick up the remains of the massive porterhouse, extracting the last scraps of heaven. The post-meal glow is full of praise for what we had so ravenously consumed.

Finally outside and ready to depart, I ask him the question I've been thinking about for days, the last social hurdle before legally changing my name. I tell him my plans to change my full name, including his family name, before asking him how that makes him feel. He tells me that he doesn't care what my name is—first, middle or last—so long as I'm happy. I am overwhelmingly relieved and glad as we hug and depart.

MAKING

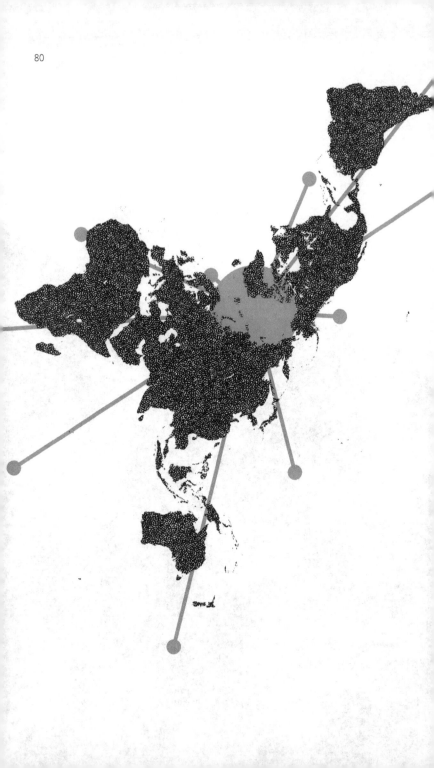

We need our stories heard to humanize difference in both others and ourselves. Complexly realized identities are difficult to abbreviate, often assumed to be the worst by those unwilling to listen. They say that the safest way to navigate a dangerous place is to look like you know where you're going, stuttering seen as weakness, making us vulnerable to the desires and ideas of others. Stubbornness becomes a survival technique and a way forward. Sometimes we push forward without knowing where we're going. We do so out of hope or displeasure, boredom even. Venturing forward, we might discover that we knew our own voices all along, formerly drowned in a sea of competition.

As I ponder using both the terms *nonbinary* and *woman* to describe myself, it feels to me an odd juxtaposition, things that shouldn't be combined, binary and non, but there is a sort of complexity it hints at. Nonbinary remains a queer category. Recognition outside of queer spaces is almost non-existent. Consciously or unconsciously, most people will place you into one of two categories, female or male, woman or man. And so, sometimes we need code switching. Using different ways to describe yourself in different spaces isn't dishonesty, but a representation of the relationality of identity. One can be a

person of color in Idaho, but not in Queens, a woman in the office and a boy in the home. We change with the landscape as we reflect relations. For now, I call myself a *girl*, almost never a *woman*. A girl may be allowed the freedom to do it wrong or in whatever way one sees fit. It's okay for a girl to be a tomboy and to play with dinosaurs. A girl might be provided an opportunity to play, experiment and fail, the expansive affordances of childhood.

The ways in which we are seen and categorized by others aren't always stable. One Sunday at my local bodega, the woman behind the counter asks *what you want mami* and the next week, she unthinkingly swaps *mami* for *papi* following an unstable intuition that confuses more than it reveals. It's easy to draw parallels with my experiences in Morocco, distinct ethnic images in conflict. Our path in life is rarely a linear road. Instead, it is often winding and scattered, confusing and straying. Sometimes you see where you're going and other times are led astray. Sometimes we hit a dead end or a wall. The path forces us to retrace our steps or to stay put. Sometimes we are this, other times that, often a complex interplay between the two. It's okay to misstep and to explore. Trial and error are often the only ways forward.

We may choose one aspect of ourselves to present to others, especially if it aligns with how others see us. Some come to

identify with how they are seen.[8] Others may assert an identity that comes into conflict with how others perceive us.[9] The subjective construction of race, which is always context-dependent, can be challenging when trying to express a personal identity.

Sometimes, we seek to be nothing, liberated from stereotypes and association. We don't have to worry about doing it wrong if we acknowledge there's no right way to be and we refuse categorization. It becomes a safety net below the high wire. Without it, we know what falling feels like without ever having taken a step. We may never move forward, for fear of death. We can't all have the confidence of the pioneer. And so we sit atop the high platforms, frozen from vertigo as we straddle the metal beneath us, convinced that forward is not a way across, but instead a drop down, envisioning our mangled faces spread across the viscera of our lives. Instead, we lower the stakes, seeing ourselves forward.

8 Such as Obama does (see Asked to Declare His Race, Obama Checks 'Black': nyti.ms/2SFPOhG). In his case, this meant being treated as a black man, a legacy of white hegemony and the one-drop rule. Subsequently, he embodies a black experience.

9 For example, Fredi Washington, a performance artist and civil rights activist who had African and European ancestry, proudly identified herself as a black woman despite often being seen as white. "I am an American citizen and by God, we all have inalienable rights and wherever those rights are tampered with, there is nothing left to do but fight...and I fight. How many people do you think there are in this country who do not have mixed blood? There's very few, if any. What makes us who we are, are our culture and experience. No matter how white I look, on the inside I feel black. There are many whites who are mixed blood, but still go by white. Why such a big deal if I go as Negro? Because people can't believe that I am proud to be a Negro and not white. To prove I don't buy white superiority, I chose to be a Negro."—Fredi Washington in Earl Conrad's "Pass Or Not To Pass?" from *The Chicago Defender*, 1945.

Many spend their entire lives trying to fit neatly into the boxes society entraps us with, while others seek freedom from a priori categorizations, the freedom to simply *be*. Every time someone sees us *as we are* and *as we are not*, we are confronted with questions of being. We shouldn't be afraid to claim multitudes—it's okay to be a chameleon, to be both and neither, to assert one element over others and to gain or lose aspects, unsure where we're headed. I can call myself queer and Asian, white and American, nonbinary and woman. I can do so exclusively or inclusively or in whatever ways I see fit. Our overlapping stories are impossible to confine to any singularity. They branch and expand, forever in conversation.

Gabriel and I both petition the court for legal name changes. Gabriel gets a pro-bono lawyer from the Transgender Legal Defense and Education Fund and I decide to represent myself. A month later, serendipity strikes—we have the same court dates despite arriving via different paths. On an otherwise normal Tuesday afternoon in July, I nervously grip Gabriel's hand as we wait in a Lower Manhattan courtroom. They're called before the judge for questioning. I anxiously await my turn, but it never comes. The judge grants our petitions immediately, waiving an archaic publication requirement and sealing our records without

any fuss. I feel overwhelming relief, but also disappointment that the state's validation means so much to me. Nevertheless, I am elated.

I surprise myself again by asking my medical provider for a letter certifying that I *have had appropriate sex reassignment treatment* and *should be considered female for all legal and documentation processes*. Immediately after receiving the letter, I rush to the DMV, then the social security office. The letter fills me with an incredible urgency, tied to the twisting landscape under the Trump administration. My head is filled with incoming reports of trans women being stripped of their female status.[10] Waiting at a grand old post office near Penn Station, I fear the window closing as I double and triple-check my passport paperwork for precision before racing to submit my documents. I type my case number into the State Department's status form nearly every day for the next few weeks. To my relief, everything goes well. I rip open the thick mailing envelope and can't stop staring at the profile page of my pristine new passport.

10 See Trans Women Say the State Department Is Retroactively Revoking Their Passports (bit.ly/2vyJEYt) and Is the US Government Revoking Passports for Trans People? It's Complicated. (bit.ly/2uM35gq)

apicha
community health center

400 Broadway / New York, NY 10013

o 212 334 6029 / f 212 334 7957

apicha.org

7/30/2018

Re: Morrow, Alexandra Juno

To Whom It May Concern:

I, ▊▊▊▊▊ ▊▊▊▊ ▊▊, am the medical provider of Ms. Morrow since November 2017.
In my medical opinion, Ms. Morrow is female. I have determined her female gender predominates and administered appropriate clinical treatment for the new female gender.

As a result, Ms. Morrow has had appropriate sex reassignment treatment and has now successfully undergone all medical procedures necessary to transition from male to female. Ms. Morrow should be considered female for all legal and documentation purposes; including on her passport, birth certificate, driver's license, and social security records. Indicating her gender as female is accurate and will eliminate the considerable confusion and bias Ms. Morrow encounters when using identification that does not reflect her current true gender.

I declare under penalty of perjury under the laws of the United States that the forgoing is true and correct.

I, ▊▊▊▊▊ MD, reviewed and evaluated the medical history of Ms. Morrow in relation to her change in gender.

_____ MD

State of New York)
)ss
County of New York)

On the 31ˢᵗ day of July_____, 2018, before me the undersigned, personally appeared ▊▊▊▊ ▊▊ ▊▊▊▊ personally known to me or proved to me on the basis of satisfactory evidence to be the individual whose name is subscribed to the within instrument, and acknowledged to me that they executed the same in their capacity, and that by their signature on the instrument the individual executed the instrument.

Notary Public

07/17/2018
Date

NYC CIVIL COURT
NEW YORK COUNTY

JUL 1 7 2018

CERTIFIED COPY OF
ORIGINAL PAPER
ON FILE

Judge, Civil Court
Honorable Debra Rose Samuels

shall be known by the name (First) **JUNO** (Middle)

New York }ss
New York }

RAZZAQ, First Deputy Chief Clerk of the Civil Court of New York, DO HEREBY CERTIFY THAT ... s of the foregoing order for change of name, ...lied with.
S WHEREOF, I have hereunto set ... day of
1 7 2018 20

Civil Court
of the
City of New York.
JUL 1 7 2018
ENTER
NE...

P USA
MORROW
JUNO ALEXANDRA
UNITED STATES OF AMERICA
07 Oct 1986
CALIFORNIA, U.S.A.
10 Aug 2018
09 Aug 2028 F
United States
Department of State

P<USAMORROW<<...<<<<<<<

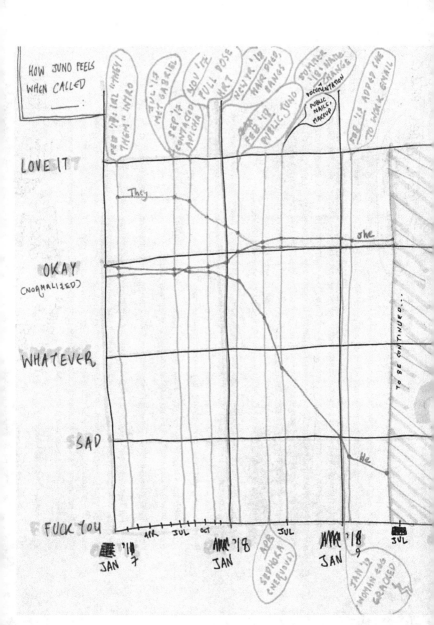

HOW DO WE FEEL ABOUT PRONOUNS

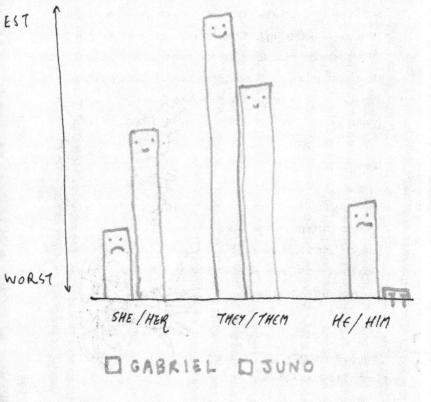

Marginalia Acknowledgements

Writing has always been difficult for me. A few years ago, my department chair suggested that I apply for a writing fellowship for tenure-track CUNY faculty, the Faculty Fellowship Publication Program (FFPP). At the time, it didn't feel like a great fit; I thought of myself as a visual artist and not a writer. A few years later I found myself applying to the fellowship, and a year and a half after that, here I am with a published book that somehow reconciled my (creative) identity crisis. Thank you to all the FFPP folks whose invaluable feedback made this book possible: Bridgett Davis, Heather Huggins, Bryan Betancur, Laurie Woodard, Andrew Demirjian, Daphnie Sicre and Darrel Holnes. Before that, I sat on this project for nearly six months without anything substantive. Without FFPP and the support of my writing group, it would have never gone anywhere.

Thank you to all the friends, colleagues and contacts who gave me feedback or supported this project in some way: Duncan Ranslem, Juniper Moon, Greg Lawson, Kalani Catbagan, Casey Plett, Andy London, Alisa Roost, Víctor Torres-Vélez, Chuck Kuan, Alan William Holt and whoever I'm forgetting (sorry).

Thank you to all the trans writers who inspired me to share my thoughts, feelings and experiences, including Casey Plett, Torrey Peters, Imogen Binnie and Gwen Benaway.

Thank you to my MFA thesis writing advisor, Ethan Silverman, who was the first person to convince me that I could be a good writer.

Thank you to my grandmother, Judy, who fostered my intellectual curiosity early on and instilled the importance of personal ethics and responsibility. Thank you to my mother, Patricia, who taught me how to be considerate and open-minded. Thank you to my father, Victor, who taught me that work is never done. Thank you to my aunt, Sandra, who showed me rated R movies when no one else would. Thank you to Jaimie who was always so chill about the important things. Thank you to Andel for saving me from the darkness of 2012. Thank you to all my family and friends mentioned in the book, who will hopefully forgive me after reading this. ~~Although, Kishore is a goddamned ICE lawyer now, so fuck him~~. Sorry, Kishore.

Thank you to Christoph Paul and Leza Cantoral of CLASH, who ran with this unusual book. Also, thank you to Matthew Revert for the cover and preserving the interior!

Most of all, thank you to Gabriel, my loving partner and unrelenting supporter, who made me a much stronger person than I was before we met. While I worked on this project, they never stopped reading, listening and providing invaluable feedback. My life is drastically better with them in it.

Also, thank you for reading this book! (:

Juno

Juno Morrow is a multidisciplinary artist, independent game designer, photographer and educator living in Brooklyn, New York. She is an Assistant Professor of Game Design and Unit Coordinator at the City University of New York's Eugenio María de Hostos Community College. At Hostos, she has been developing the game design program, the first public degree program of its kind in New York City, since 2015. Prior to that, Morrow earned an MFA in Design and Technology from Parsons School of Design. As an internationally exhibiting artist and designer, Morrow has presented games and spoken at sites such as SXSW, GDC, MAGFest and the Smithsonian American Art Museum. With over 10 years of experience as an award-winning photographer, she's had work featured in *The Guardian*, *Dwell* magazine and released 3 monographs of urban photography.

Her unusual games, often infused with dark humor, feature distinctive aesthetics and novel premises. Examples include *Oral Perspectives*, a VR game taking place inside the player's mouth, and *Mastering Tedium*, an existentialist laundry simulator played inside a text terminal. Recent work includes *Pruuds vs. Sloots*, a "dumb versus game," and *Blood Broker*, a consent-based human sacrifice management simulator.

junomorrow.com

cyclopedias for fundamental anatomy lessons. I would sit in the shower under the sca
r, staring at my penis. I would sometimes invert it inside itself and wondered if this wa
o be a girl. During this time, I learned in elementary school about the injustices black sla
the hands of white enslavers. I knew that black and white people existed and yet no or
to fit the description. If I had asked my classmates at the time which category they
gine most giving a fuzzy sort of confirmation, limited by the naive and fragmentary k
dren have of the grown-up world, a world that is abstract, free of both context an

Constructed of words, artwork, photos and personal artifacts, *Marginalia* is an intimate and unconventional account of what it means to be a hybrid. It seamlessly interweaves experience with elements of sociology and psychology, exploring how one cultivates an identity containing multitudes — queer, trans, mixed-race, *other*.

junomorrow.com

new much about the Philippines growing up, other than it was a place that someone in r
ne from in the remote past. When I would ask my mother about that lineage, she wo
ings down into negligible fractions, sometimes describing this part of myself as 1/8th
something to acknowledge and minimize, a small blip in an otherwise mostly Irish a
l brew. Always ancestry and family, never race. Distant descriptions, not modes of f
ng to the hegemonic group, you are allowed freedom from identity, an unhyphenated
immer I would board a plane to spend time with my father in Dallas. He seemed to

9 781944 866679